Love

First published 2019 by order of the
Tate Trustees by Tate Publishing,
a division of Tate Enterprises Ltd,
Millbank, London SW1P 4RG
www.tate.org.uk/publishing

A catalogue record for this book is
available from the British Library

ISBN 978 1 84976 655 5

Distributed in the United States and
Canada by ABRAMS, New York
Library of Congress Control Number
applied for.

Project Editor: Emilia Will
Production Controller: Roanne Marner
Picture Researcher: Deborah Metherell
Designed by Joe Ewart
Colour reproduction by
DL Imaging Ltd, London
Printed and bound in China
by C&C Offset Printing Co., Ltd

Pages 4–5: Charlie Phillips, *Notting Hill
Couple* 1967 (detail, pp.76–7)

Measurements of artworks are given in
centimetres, height before width.

Author's Acknowledgements: Thanks to
Jane Ace, Hannah Barton, Priya Bose,
Holly Callaghan, Camille Gajewski,
Christopher Griffin, Aya Kaido, Christine
Kurpiel, Dana Mokaddem, Kee Somasiri,
Lupe Núñez-Fernández, Jenny Wilson and
Emilia Will.

For Kee (the centre, always)

Alex Pilcher's previous book, *A Queer
Little History of Art*, is also available from
Tate Publishing.

Love

Alex Pilcher

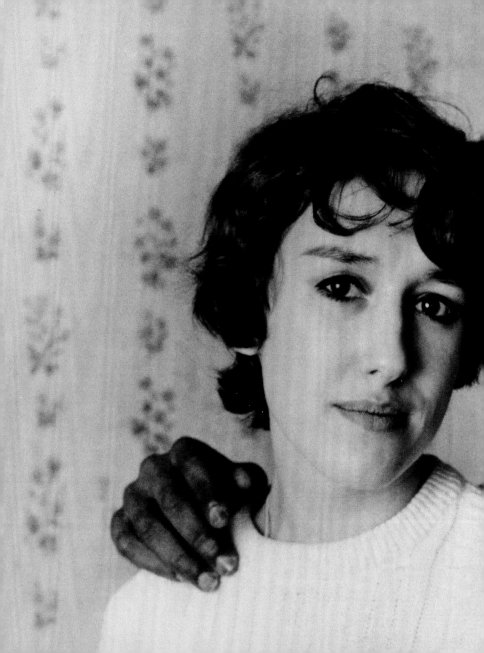

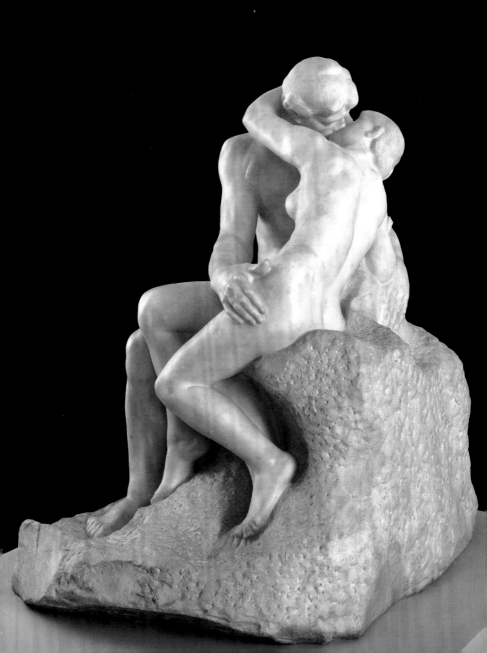

Introduction

Among the sights that greet visitors to Tate's galleries, one constant favourite is the sculpture opposite, titled, simply, *The Kiss*. Hewn from a vast block of marble, this monumental snog certainly draws attention to itself. Many who circle around this tangle of naked limbs discover a more private side to its allure, as they trace echoes of intimate encounters, recently enjoyed or only dimly remembered. Auguste Rodin's classic celebration of passion provides a good starting point for exploring art's relationship with romantic love.

The familiarity, even notoriety of *The Kiss* has caused us to lose sight of how the sculpture's sensuality struck its first viewers. This couple was a hit from the moment that Rodin exhibited his primary, plaster and bronze versions in 1887. Several hundred casts and replicas ensued – produced at various scales to meet demand – including three massive versions in marble, of which Tate's is one. The appetite for copies gives a hint of the excitement that Rodin's eroticism, mild to our eyes, represented to his contemporaries.

The Kiss was not an amorous blip, but part of a tumultuous moment in the history of Western art when the

Auguste Rodin
The Kiss 1901–4

forces of sexual attraction and arousal were acknowledged with new-found directness. Our gift for forging emotional attachments accompanied by the throb of physical desire is an ancient one. But it was not a side to human nature artists of Christian Europe raced to honour. Long stretches of art history leave the impression that only Greek gods and nymphs were permitted to desire with dignity. Though there are touching exceptions from before the modern era, Western artworks censured more than they celebrated amorous feelings among mortals – sensual craving being recurrently linked to folly, vanity or carnal sin. In *The Kiss*, old scruples seem to fall away (along with the marble couple's clothes).

Artists did not embrace amorous desire overnight. From the eighteenth century, successive artistic fashions introduced modes of exploring love that were less sternly moralising. The earlier artworks in this book are part of that story. The Rococo era discovered flirting's appeal as an elegant pastime for privileged classes (p.14). The romantics turned to literature for colourful tales of passion – even if those passions often proved doomed (p.22). Next came realists, crafting small-scale dramas from the emotional snags of contemporary life (p.65). In contrast, Rodin's symbolist contemporaries elevated sexual love into a universal principle, floating free of narrative particulars (p.17). *The Kiss* certainly leans in the latter direction, though its literary source was a favourite text for Rodin's romantic forerunners. The lovers were originally named as Francesca da Rimini and Paolo Malatesta: a pair of

thirteenth-century adulterers whose cursed spirits sigh out their pitiable tale in Dante's *Inferno* (see p.22). By the time the work became widely known, Rodin had dropped the historical identifications, accepting that the couple's new fate was to embody a generalised concept of love.

No artwork can capture what love means for every viewer – let alone for all time. If historical costumes are discarded in *The Kiss*, the lovers are clothed in a sexual worldview that dates them nonetheless. Rodin fixated on heterosexual desire with an ambivalence common among European, male artists working near the turn of the twentieth century: elevating it as a mystical life force while appearing perturbed by unconstrained female sexuality (it is Francesca's snaky embrace that seals Paolo's doom).

Since the sculptor's chisel finished its work, our expectations of love and relationships have been repeatedly rewritten. As this selection from Tate shows, art of the last two centuries has kept pace with our ever-shifting outlook on matters of the heart and sometimes encouraged us to imagine new directions. If not all love stories received equal validation in the past, omissions and biases have goaded artists towards narratives once sidelined. And while there are still reasons to be wary of love's pull, the bleak, romantic pessimism of our ancestors no longer holds such sway. The enduring popularity of *The Kiss*, meanwhile, is a firm indication that love – uplifting, compulsive, inspiring, dangerous and perennially seductive – will never cease to reel us in.

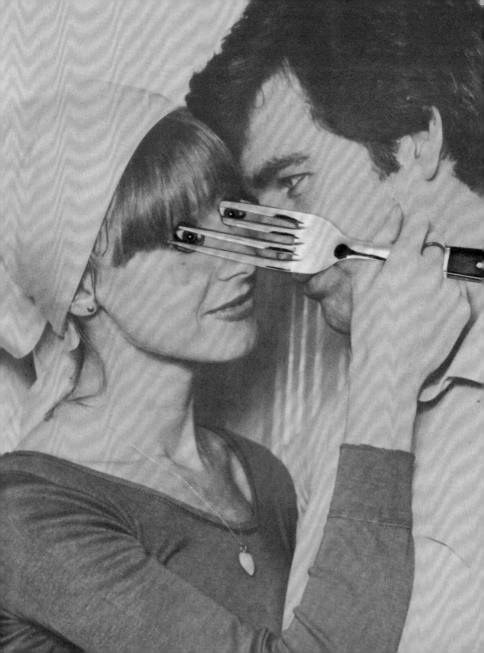

Making Eyes

From the perspectives of those involved, the drama of awakening love invites hyperbole. Worlds turn upside down; strangers emit dazzling light; stars collide. Such commotion can be hard for bystanders to discern. Indeed, the whole business may seem relatively subdued – as though lovers' energies are exhausted by the emotional mayhem. But even if those struck by love are sometimes frozen to the spot, expressive fire is reliably present in every look and glance. The many varieties of amorous looking – from the meltingly soulful to the flirtatiously provocative – have in turn been lovingly observed by artists. It's not uncommon for an artwork's romantic plot to be distilled within a yearning gaze or a downcast eye.

The images in this first section are laced with loving looks. Their taut sightlines can resonate for sympathetic viewers as much as for the actors in the scene. Looking at art is very often a wide-eyed encounter with beauty's charms and enthusiastic beholders sometimes speak of falling 'in love at first sight' with favourite works of art. Faced with art on the theme of visual attraction, susceptible viewers may find themselves drawn into a triangle of admiring eyes.

Opposite: Linder, *Untitled* (detail, p.19)

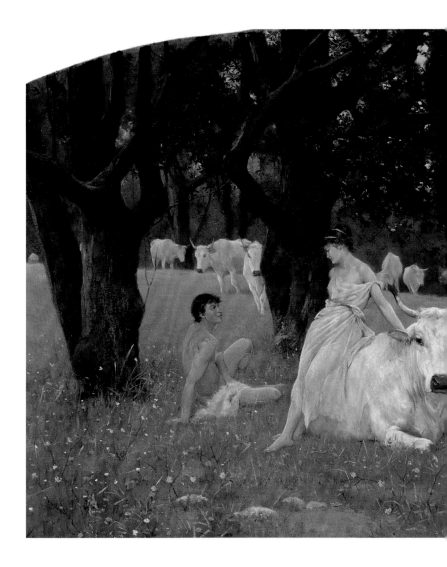

Arthur Lemon

The Wooing of Daphnis
exhibited 1881

The pastoral love story of Daphnis
and Chloë hails from second-
century Greece but inspired a
good crop of modern retellings. In
Arthur Lemon's tranquil painting
the young protagonists fall under
love's spell. The cattle plodding in
the background provide a quietly
animated contrast to their stock-still
human attendants, transfixed by their
dawning mutual attraction.

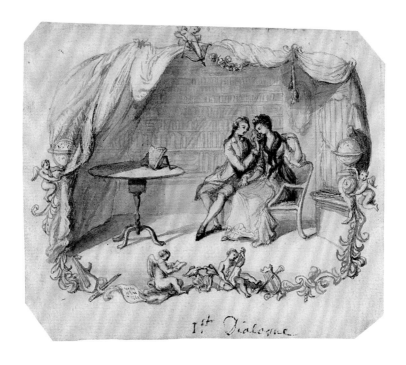

1st Dialogue

Susanna Duncombe (née Susanna Highmore)
Vignette with Cupids and a Courting Couple in a Library n.d.

A dance of hands, heads and S-shaped torsos evokes those giddy moments when mutual attraction is felt in every limb. Susanna Duncombe's artistic and literary ambitions set her apart from women of her day, but here she assigns stereotypical gendered actions to her lovers. Feminine modesty contrasts with the urgent desire of the man's twisting posture and enamoured gaze.

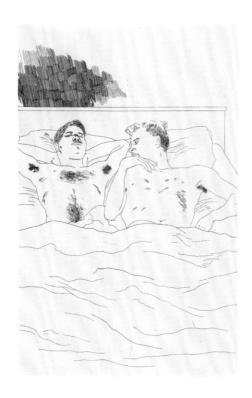

David Hockney
In the Dull Village from *Illustrations for Fourteen Poems
from C.P. Cavafy* 1966–7

David Hockney's etchings to poems by Constantine P. Cavafy pay elegant
homage to a treasured gay ancestor. Rather than recreate the Alexandria
of Cavafy's day, Hockney posed local models in his own London bedroom.
Here, one man contemplates the companion who slumbers beside him,
suggesting the awakening of feelings set to outlast this night.

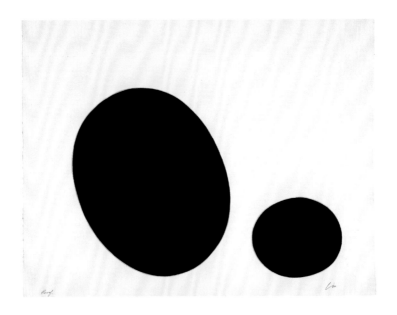

Richard Lin

Flirtation 1965

Two ovals tilt towards one another as though animated by same-shape attraction. The recognition of a desirable match has rarely been dramatised in terms as abstract as Richard Lin's minimalist romance. Softening the severe geometry, a subtle ribbon of yellow ink surrounds each black form like a sensitive outer membrane.

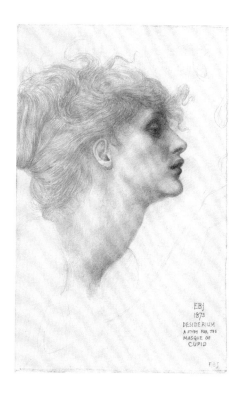

Edward Burne-Jones
Desiderium 1873

This study in yearning was to be but one detail of a crowded allegorical
tableau. Edward Burne-Jones ditched ambitious designs for *The Masque
of Cupid*, which would have featured his breathy personification of
Desire coaxing flames from a handful of embers. Shorn of such clunky
symbolism, this elegant fragment is perfectly self-sufficient, distilling an
essence of romantic fixation in its trance-like stare.

Linder

Untitled 1976

In Linder's punk-feminist collage, the man's eyes drill into those of his partner with comic exaggeration. Hers have undergone a twisted makeover – additions cut from magazine pages being grafted on with horrific precision. The woman's shocking act of self-harm, erupting within a model heterosexual romance, may offer a seditious warning to her sisters under patriarchy.

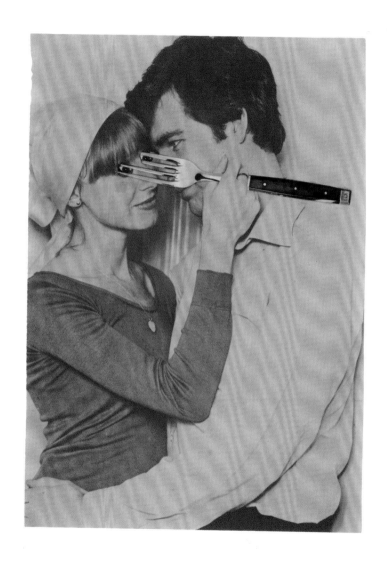

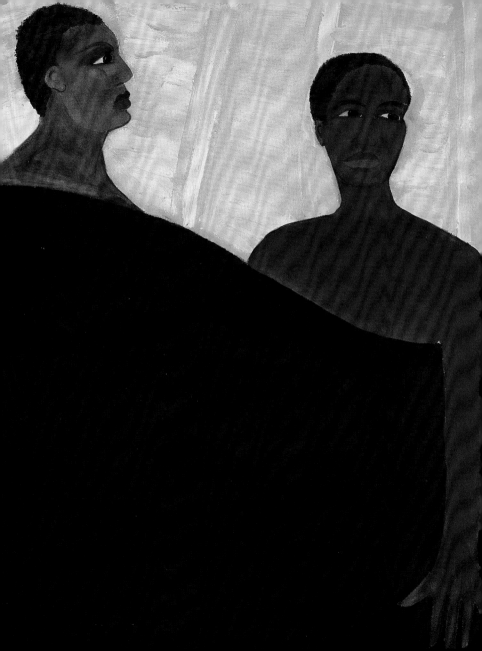

Courting Trouble

Lovers don't always require outside assistance to blight each other's happiness but, alas, it often comes their way. Human societies have policed love's expressions with dogged vigilance and frequently punished those whose affections strayed over one carefully guarded boundary or another. It's tempting to glibly celebrate love's fearlessness in the face of prejudice and prohibition. But the costs lovers have been made to bear are staggering: from insults, violence and parental outrage all the way to sentences of death and threats of further torment beyond the grave (p.22).

Thankfully, norms that stipulate how or whom we may love are not impregnable and noncompliant hearts can attract their own champions. In art and culture, we see the frontlines of romantic dissent shift over time. In the nineteenth century, sympathy might be extended to liaisons across class frontiers (p.24) and even to adultery (if poetically distant in time, p.6). Twentieth-century rebels grappled more urgently with the divisions etched by racism (p.25) and restrictions on sexual expression (p.28). Yet when it comes to social change, love is not merely a cause to rally around. In the struggle for justice, it can often be personal loyalties and ties of affection that rouse the public activist within us (p.30).

Opposite: Lubaina Himid, *Ankledeep* (detail, p.31)

William Blake

*The Circle of the Lustful: Francesca da Rimini
('The Whirlwind of Lovers')* 1826–7, reprinted 1892

Our metaphors cast love as gravity's foe. While we 'float on air', 'fall deeply' or are 'swept off our feet', everyday moorings unravel. Impelled by inexorable forces, lovers have tumbled over barriers – personal, cultural or legal – that commonly restrain behaviour. Dante Alighieri gave poetic form to this perilous weightlessness in his visionary survey of Hell. For succumbing to excesses of love (in the eyes of the medieval church), souls in the second tier of punishment are blasted through the darkness on eternal, howling winds. Among Dante's many illustrators, William Blake renders this scene from *Inferno* with unique graphic potency.

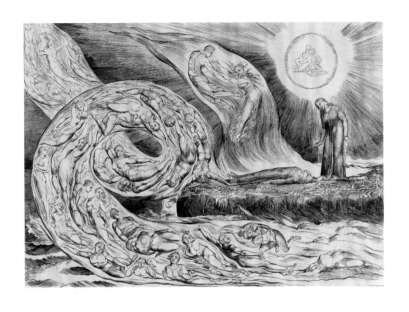

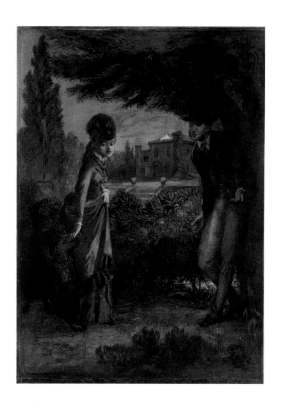

Unknown artist, Britain

Lovers Meeting by Moonlight in a Garden 1869

A young woman roams the grounds of her family home to keep a
nocturnal appointment behind the bushes. The ardent man awaiting
her looks unlikely to be her social equal and, for Victorians, this class
difference alone would have merited the anxious secrecy. A crucifix hangs
conspicuously against the woman's bosom: a talisman against the dangers
that their unruly hearts pose to her virtue and social standing alike.

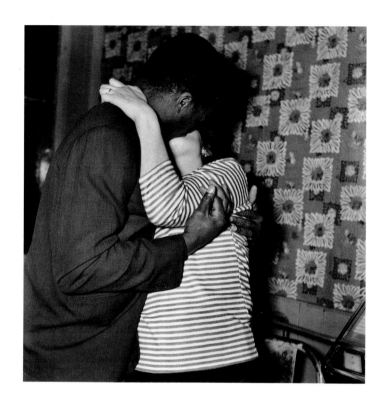

Bandele 'Tex' Ajetunmobi

Couple Kissing, Whitechapel, London c.1960s, printed 2012

These lovers caress in the sanctuary of an East End nightspot corner.
At the time Bandele Ajetunmobi captured their tender kiss, many
white Londoners were affronted by love that jumped lines of culture or
ethnicity. In other spaces of the city, similar couples faced disapproval and
racist animosity.

Gwen John

Dorelia in a Black Dress c.1903–4

In a two-year contest for the attention of their new-found idol Dorelia McNeill, sibling artists Gwen and Augustus John cast propriety aside. In 1903, while Augustus pressed his wife to embrace his polyamory, Gwen enticed Dorelia to France with a plan to cross Europe on foot, exploiting the interlude to scrutinise her companion in their dimly lit lodgings.

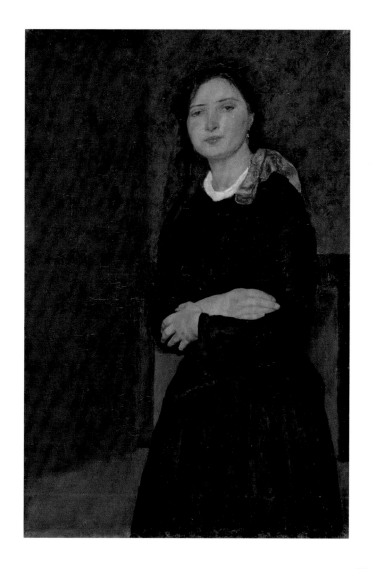

Tracey Emin

Is Anal Sex Legal 1998

Tracey Emin

Is Legal Sex Anal 1998

Is Anal Sex Legal? was a question worth asking in 1990s Britain. England's Tudor buggery laws were not fully annulled until 2003. Within living memory, anal intercourse was still criminalised for all genders. But lawmakers' attempts to prohibit 'unnatural' love have had limited authority in the bedrooms of a desiring populace. Tracey Emin's cheekily inverted question, *Is Legal Sex Anal*? may have chimed with queer lovers, for whom flouting homophobic laws became almost a badge of honour.

Lubaina Himid

Ankledeep 1991

Ankledeep is drawn from Lubaina Himid's series, *Revenge*. As the collective title indicates, these vibrant canvases reckon with a dismal past – turquoise brushstrokes and intense blues alluding to the waters of the Middle Passage that bore millions towards death or captivity. *Revenge* is punctuated with women in dialogue. These two occupy the shoreline, shredding the maps that enabled Europe's traffic in humans over four centuries. A curling black banner shields naked bodies from objectifying eyes. It's a hint that both solidarity and intimacy sustain this alliance: a radical love grounding the women's strategies for resistance and change.

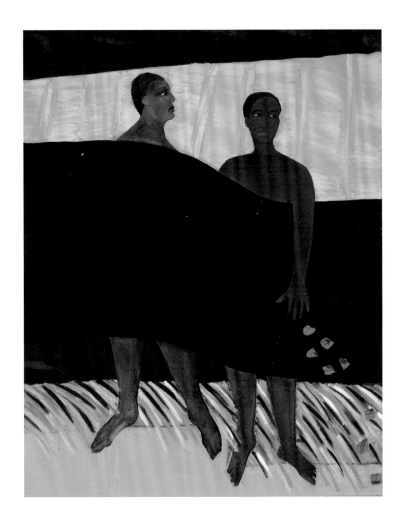

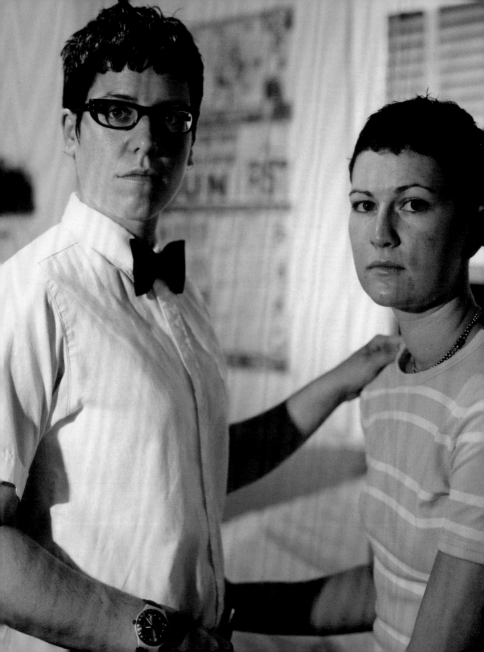

Tying Knots

From customary vows in public ceremonies to improvised, low-key affirmations, there are countless ways for lovers to declare commitment to each other. A profound, enduring bond is not the bar of success for every intimate relationship. Still, the transformative effect of statements as plain as 'I love you' exposes how regularly we crave special status in the affections of others, whether romantic partners or close friends.

Historically, wedlock – while no guarantee of sincere affection – has been a uniquely favoured pledge of attachment. This socially sanctioned paradigm of intimacy has left many traces in the history of art. Marriage, however, has never been a universal option – even for those who might desire it. Restrictions based on creed, caste, gender, race and wealth have barred many from a rite that remains tightly regulated. What laws and institutions disallow, art can facilitate. The works in this section by Sylvia Sleigh (p.38), Catherine Opie (p.41) and Felix Gonzalez-Torres (p.44) can be viewed as professions of love that found creative paths around the impossibility of marriage at the time of their making.

Opposite: Catherine Opie, *Melissa & Lake, Durham, North Carolina* (detail, p.41)

Christopher Wool

Untitled 1997

Complete? Sick? Happy? Furious? Dizzy? The top-heavy placement
of Christopher Wool's stencilled text implies more might follow – the
ambiguous declaration a reminder, perhaps, that amorous avowals are
never the final word on our feelings for the other.

YOU MAKE ME

Lawrence Alma-Tadema

A Foregone Conclusion 1885

Henry Tate ordered *A Foregone Conclusion* as a gift for Amy Hislop, his younger fiancée. Lawrence Alma-Tadema flatters the Tate Gallery founder with this classical, marriage-proposal drama. The young Roman, ring in hand, may be rehearsing his lines as he approaches, but the answer, we are told, is a given.

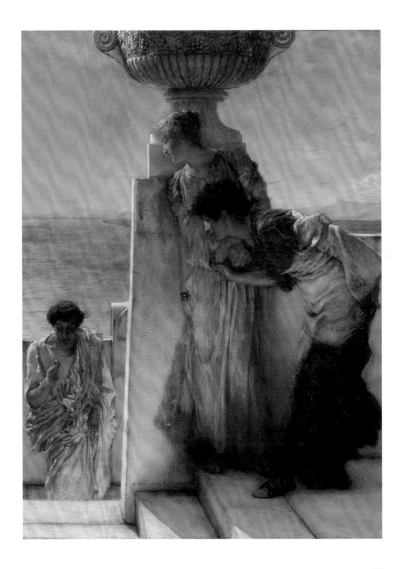

Sylvia Sleigh

The Bride (Lawrence Alloway) 1949

Sylvia Sleigh was already wed when she met her true life partner and wouldn't get to marry art critic Lawrence Alloway for a further decade. Meanwhile, their furtive liaison spawned playful personae, including this female alter ego modelled by Alloway: a wedding portrait five years ahead of their union.

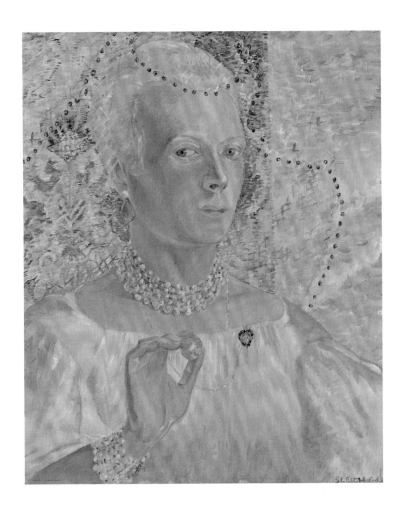

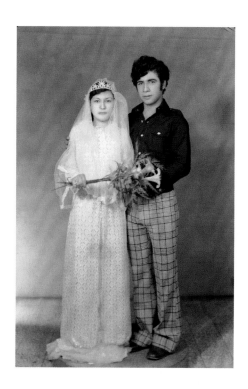

Akram Zaatari

Objects of study: Hashem el Madani, Studio Practices 2007

Photographer Hashem el Madani saw many wedded clients at his Saida
studio, such as this Palestinian couple from the nearby Ain el-Hilweh
refugee camp. The young subjects in this image from the early 1970s
stand on their dais as stiffly as figurines – an artificial note underscored by
the plastic flowers and vintage retouching. Yet the tender earnestness in
these eyes is real enough.

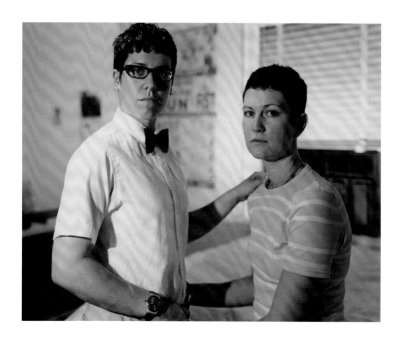

Catherine Opie

Melissa & Lake, Durham, North Carolina 1998

In the late 1990s, Catherine Opie set out to alleviate a shortage of queer portrayals of family life. With her large-format camera, she drove 9,000 miles across America visiting lesbian households. The solemn poses of Melissa and Lake reflect norms common in marriage portraiture, foreshadowing expanded possibilities for same-gender love. Marriage equality for US couples lay seventeen years off.

Sophie Calle

The Hotel, Room 29 1981

After a three-week stint servicing rooms in a Venice hotel, Sophie Calle documented each set of guests' scattered belongings in a series of oblique portraits. A revealing find in Room 29 leaves the undercover artist 'very moved'; the occupants are a young couple, just married. Calle's inventory fuels our imagination about their honeymoon story (and our anxieties about hotel privacy).

ROOM 29

Saturday, February 28, 1981. 10:15 a.m. I point to room 29. The twin beds have been slept in. On the table, some leftovers in a plate, two glasses, a bottle of water, some Diana cigarette butts in the ashtray. It seems to me at first that the room has been vacated. Then I notice a pair of vents shoes sticking out from under the wardrobe, a white cigarette Sergio idol hanging on the coat-rack. In the bathroom, toiletries: razor, soap, a wash-cloth, comb, red, still in its package, the other one yellow, in a blue plastic case, an Italian toothpaste, a big white sponge. Nothing else. I open the wardrobe. Inside I find a large hand suitcase, a handbag, a small suitcase, a plastic bag containing two pairs of slippers (size Stendl 41), two yellow sweaters and lying with a suitcase, a cardboard-covered notebook with the inscription: "Ricordo de matrimonio" (Wedding souvenir). I leaf through it, very moved. C.S. born in Pisa in 1958 and F.C. born in Pisa in 1957 were married on February 26, 1981 at eleven o'clock in Concionella. My first couple on a honeymoon. In the handbag I find some cigarettes and a white handkerchief; in the small suitcase some toilet articles. And in the bigger suitcase, a large white towel, a white shirt, a pair of a blue panties, a white embroidered slip, a pair of black socks. I clean the room, make the bed, lifting the sheets, I find their two pajamas, a white one with small red and blue flowers, the other in blue flanelette, and a long black hair.

Sunday March 1, 9:30 a.m. They have gone. I clean up the room.

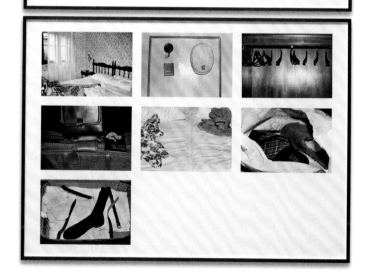

Felix Gonzalez-Torres

"Untitled" (Double Portrait) 1991

Printed in gold ink on each sheet of a stack of paper that may be continually replenished, the conjoined rings of *"Untitled" (Double Portrait)* can be interpreted as a symbol of true love to which viewers may help themselves. Felix Gonzalez-Torres conceived this work in the year he lost life partner Ross Laycock to AIDS-related illness and while the artist was most interested in the work being contextualised in new and different ways each time it was exhibited, the work has often been situated within the framework of the cruel impact of the AIDS crisis.

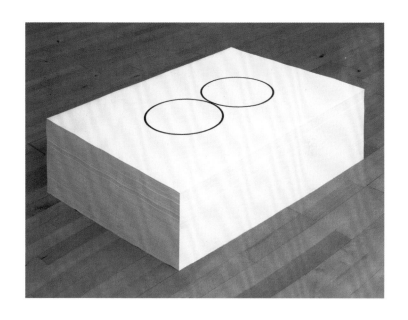

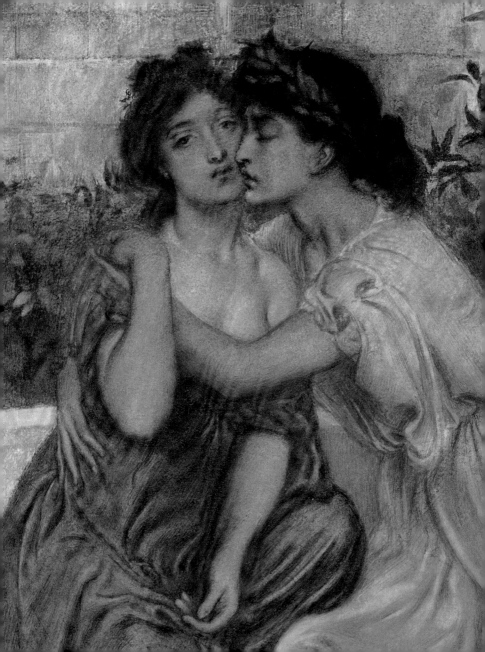

Getting Down

Love and sex, we have all been taught, are not the same thing. But while moralists and educators stress the distinction, many a lover could attest to thrilling crossovers. Pleasurable contact between willing bodies can induce a heady rush of appreciation for the companion of the hour. The emotion released in such romantic hot flashes may be short lived – a symptom of transient brain chemistry – but is it really so different in kind to admiration of longer gestation?

The history of Western art offers up no end of sexualised bodies, but surprisingly little sex. Artworks that manage to infuse erotic content with a romantic flavour are even rarer. Yet here and there, artists have succeeded in capturing touches of those bedroom feelings: from the hushed anticipation of the two lovers undressing in Edward Calvert's magical wood engraving (pp.50–1) to the satisfied repose that oozes from an abstract sculpture by Maria Bartuszová (p.60).

Opposite: Simeon Solomon, *Sappho and Erinna in a Garden at Mytilene* (detail, p.52)

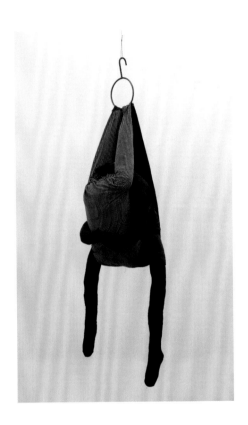

Louise Bourgeois

Couple I 1996

Despite absent body parts, *Couple I* can be read as a woman straddling a male figure. Rather than getting naked, however, these headless lovers have become a bundle of stuffed and strung-up clothes. Is Bourgeois hinting that gendered roles structure our moments of sexual intimacy as much as they regulate our everyday wardrobes?

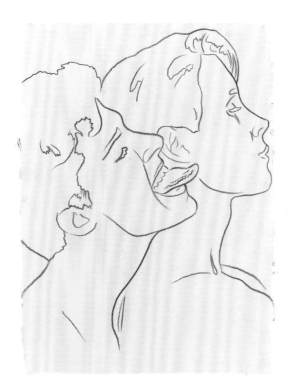

Andy Warhol

Tongue in Ear 1982

This sensual drawing is based on a Polaroid: one of several Andy Warhol photographed for a poster commission (for Rainer Werner Fassbinder's 1982 film, *Querelle*). While much of the shoot feels staged, here Warhol's models sink into each other hungrily – their tableau of simulated bliss making a fitting choice for the final poster.

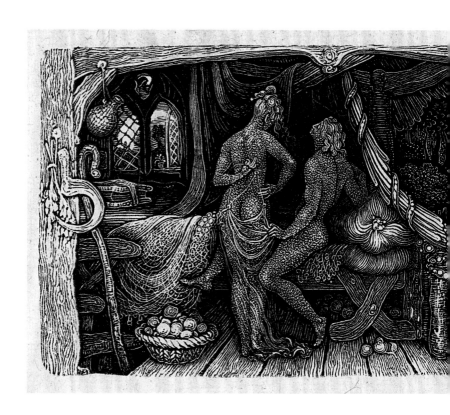

50

Edward Calvert

The Chamber Idyll 1831

As these lovers undress, their rural home merges mysteriously with the nocturnal landscape. A huge moon peers through the open casement – a voyeur, like us – while, in a rustic role-reversal, sheep keep watch for their shepherd. Conventional pictorial logic gives way to a hallucinatory atmosphere of charmed eroticism.

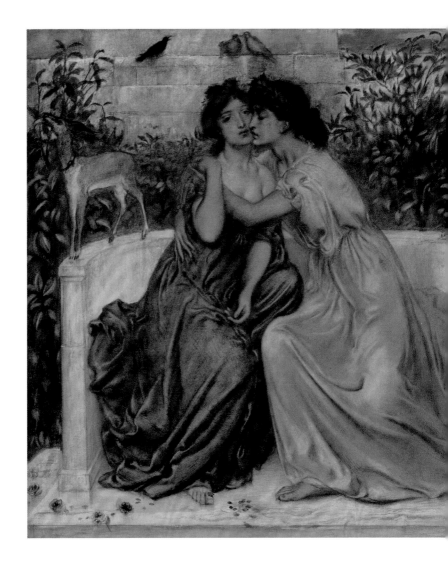

Simeon Solomon

Sappho and Erinna in a Garden at Mytilene 1864

Few historical figures earn their own adjective in love's lexicon; Sappho of Lesbos gets two. This Sapphic embrace heralds the Lesbian poet's modern rebirth as a standard-bearer for same-gender lovers, including artist Simeon Solomon. The image is both boldly sexual and curiously cool – Sappho undressing Erinna with eyes tight shut, as if busy composing one of her love lyrics.

Ithell Colquhoun

Scylla 1938

By recasting the artist's field of vision in her bathtub, this surrealist double image slyly promotes a female viewpoint on sexuality. The Scylla of Greek myth was a monster that ate the heads of unwary sailors steering too near her cave. Ithell Colquhoun's erotic symbolism is more direct and less fearful.

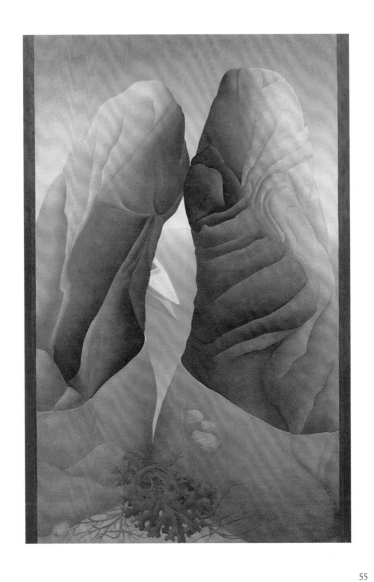

Dorothy Iannone

Wiggle Your Ass for Me 1970

These frisky avatars represent artist couple Dorothy Iannone and Dieter
Roth. The painting is from a series devoted to their sexual play, with
captions that traverse erotic dominance, submission, humour and ecstasy.
Betraying a lover's fondness for myth-making, Iannone's cross-cultural
stylistic influences lend an air of near sacred significance to an earthly
love story.

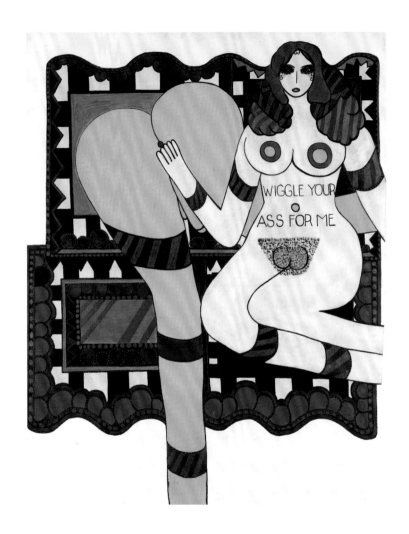

Francesca Woodman

Untitled 1975–80

Francesca Woodman's monochrome self-portraits can teeter between an unnerving intensity and deadpan humour. When this photograph is seen in isolation, the mirror on which the artist crouches seems to box her in with its heavy frame. With Woodman's handwritten message, this print – given to her then boyfriend – becomes a risqué sexual invitation.

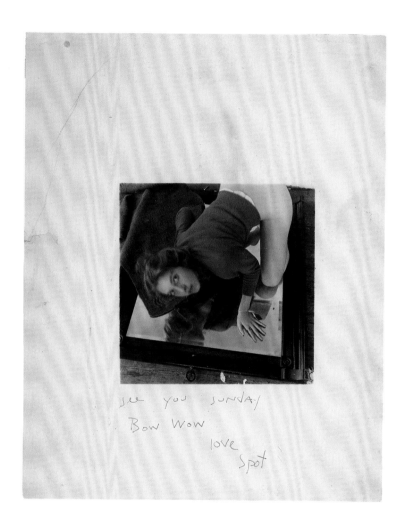

see you sunday

Bow wow

love

spot

Maria Bartuszová
Untitled 1971

Maria Bartuszová spent decades testing the expressive potential of moulded plaster – deploying latex sheaths, gravity and much careful squeezing to achieve these licked contours. The artist spoke of shapes having 'strong psychological expression'. Nuzzling, rounded forms like these might convey 'the feeling of a tender touch, of a hug – and maybe also erotic feelings'.

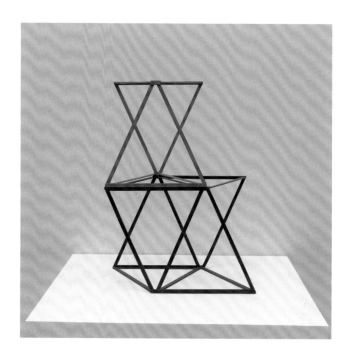

Rasheed Araeen

Lovers 1968

Lovers is a voluptuous anomaly among Rasheed Araeen's lattice
sculptures, whose sides are generally vertical. By flipping the triangular
base elements, Araeen twists the flanks of his moveable components.
Their enlivened struts lean at angles, each finding a sympathetic parallel
in some part of the beloved however they are arranged.

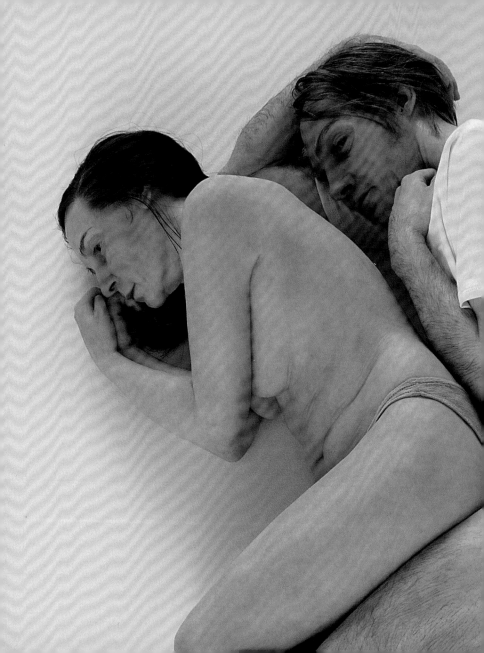

Feeling Blue

The sorrows of lovers have gifted poets, songwriters and storytellers with an inexhaustible supply of material. For visual artists, depicting the emotional toll of heartbreak, separation or unrequited love is arguably a greater challenge. It's one many artists rise to, though their frequent dependence on literary sources – including the plays of William Shakespeare (p.64) or the poetry of Dante (p.6) and Nizami Ganjavi (p.70) – seems to concede that writers have the upper hand in portraying dejected solitude.

Nineteenth-century British artists showed a particular fondness for romantic pathos. Their unfortunate lovers tremble and sigh over unobtainable or undeserving love objects, establishing visual tropes still readily legible today. Philip Hermogenes Calderon's eloquent composition (p.65) immediately alerts us to a love story gone awry, even before we unravel the clues in its details. The inky, show-stealing outfit worn by his distressed heroine also points to artists' frequent use of colour – or the lack of it – to project the melancholy of love's casualties.

Opposite: Ron Mueck, *Spooning Couple* (detail, p.73)

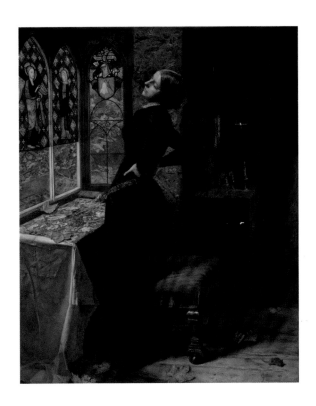

John Everett Millais

Mariana 1851

Mariana is a character in William Shakespeare's *Measure for Measure*, spurned by a powerful man who once promised marriage. Chronic frustration never dims her longing for the faithless Angelo: a state of mind Millais conveys in a pose conflating weary boredom with a hint of Mariana's sensual daydreams. Her heavily worked embroidery, meanwhile, seems to measure out her loneliness by the yard.

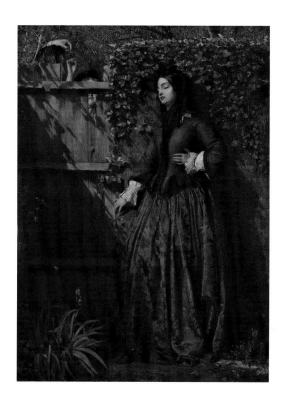

Philip Hermogenes Calderon

Broken Vows 1856

Like many a Victorian picture, *Broken Vows* is strewn with details that reward patient inspection. An iris wilts from thirst while a watering can lies abandoned among weeds. A love charm in the dirt has snapped off a fallen gold bracelet. And, at the painting's focal point, a jewelled ring finger is clasped against a fainting heart; he who gave the ring has been overheard dallying with another behind the fence.

Cindy Sherman

Untitled Film Still #27 1979

Cindy Sherman's *Untitled Film Stills* shun Victorian-style narrative. Each 'still' is an independent work, with no screenplay attached. Sherman's plot vacuum draws attention to certain well-rehearsed storylines that our visual culture primes us to fall back on – including tear-stained heartbreak: a trope entrenched by nineteenth-century artists.

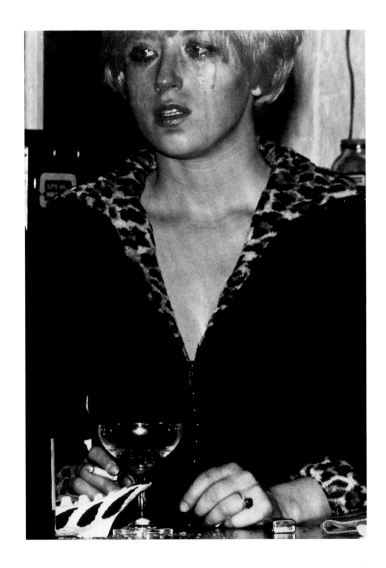

Marcus Stone

Il y en a toujours un Autre 1882

Harking back to the reign of George III, Marcus Stone's lush costume dramas star Mr Darcy wannabes – labouring to divert languid young women in muslin gowns from their obligatory sewing baskets. This crestfallen suitor's disappointment may wear off. Both the French title (which translates as 'there is always another') and his hunting garb suggest a serial chaser, already rebuffed by a string of such garden-bench needleworkers.

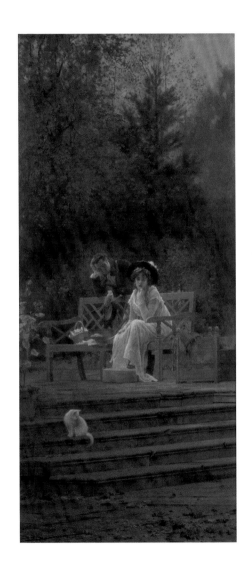

Parviz Tanavoli

The Poet and the Beloved of the King 1964–6

Despite its fairground colours, Parviz Tanavoli's sculpture draws
inspiration from one of Persian literature's more tragic legends. Nizami
Ganjavi's tale of Farhad the stone-carver and the princess Shirin features
a jealous royal rival, superhuman trials and a woeful conclusion. For
Tanavoli, Farhad represents the archetypal poet-lover – his yearning soul
represented by a sheet-metal nightingale, caged within his chest.

Agnes Martin

Faraway Love 1999

Late in life, Agnes Martin created works whose luminous hues and candid titles mark a break from her previously reticent output. The more upbeat paintings of the group, such as *Perfect Happiness*, hold bands of primary colour in balance. In *Faraway Love*, icy blue threatens to descend over the whole canvas like a mist.

Ron Mueck

Spooning Couple 2005

Ron Mueck's signature attention to detail brings his diminutive *Spooning Couple* unnervingly to life. Despite the surface proximity, a gulf seems to divide this wakeful pair who curl in on themselves: melancholy islands of solitude from whom love has sailed away.

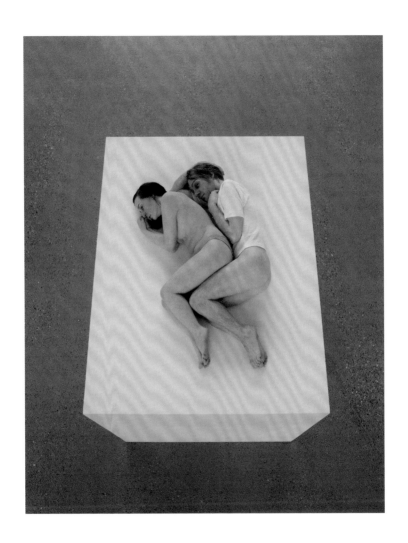

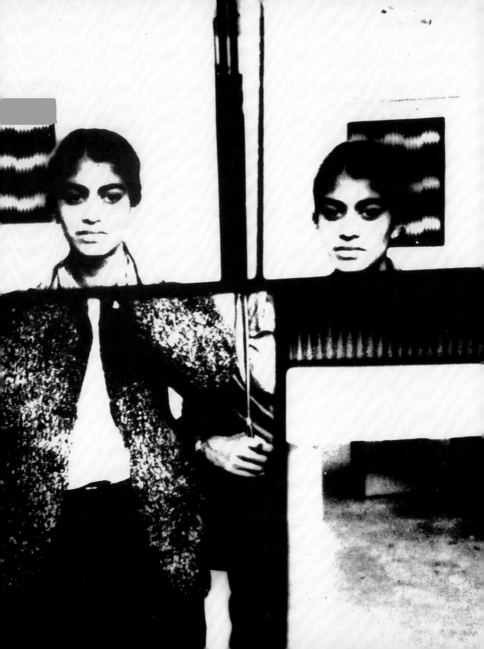

Pairing Off

The existence of a perfect match – a 'Mx Right' waiting around some corner in life – is an article of faith that unites the chronically lonely and the newly in love. It's a notion with a long history. The Greek philosopher Plato supplies an amusing origin myth for this very human quest in his *Symposium*, written in the fourth century BC. In the past, people had two faces, eight limbs and too much chutzpah, before the gods quite literally cut humanity down to size by splitting our bodies in two. Each individual born of this division faces a lifelong search for their missing 'other half'. That any of us succeed in pairing off suggests that candidates for 'the one' are, in fact, plural in number. Certainly, this is the working premise of dating apps whose algorithms – given sufficient, local data – proffer an instant menu of potential matches.

The artworks in this section invite questions about the makings of a good partnership. Do we hanker for a soul mate who shares our passions (p.81) or a comrade who 'gets' our experience (pp.78–9)? Will a perfect couple merge into a single entity (p.83) or maintain distinct identities (p.82)? Do we hunger subconsciously for our own reflection (p.84) or treasure the differences to be discovered amid likeness (p.85)?

Opposite: Jyoti Bhatt, *Venice* (or *Ardhanareshwar*) (detail, p.83)

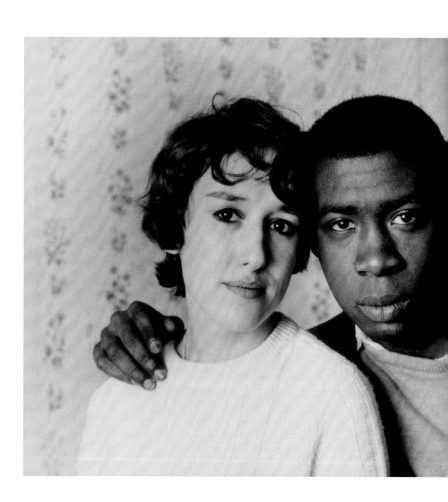

Charlie Phillips
Notting Hill Couple 1967

We may never learn the story of these unnamed Londoners; yet somehow their portrait illustrates why we thirst for connection. Heads butt with gentle familiarity in Charlie Phillips's happy composition – a string of eyes settling on the arc of an imagined smile. It's hard to resist the impression of a tie watered with enviable affection and trust.

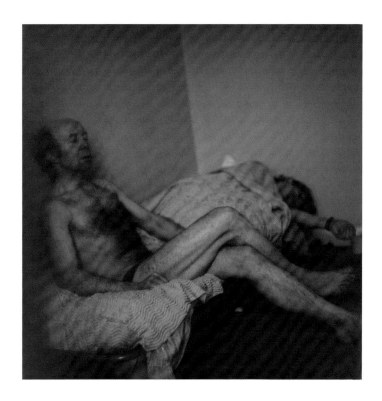

Gillian Wearing

Theresa and George 1998

Raw shared experience is enough for some connections to bloom. Gillian
Wearing's multi-part portrait of a street drinker offers seven glimpses
of Theresa paired with her occasional partners. Each man supplies
handwritten commentary, including George's lucid appraisal of why their
shared moments matter: 'we are allways under the weather drunk so we
are on the same wave lenth'.

I find her a nice girl a quiet
girl she is good to talk to
very chatty she is alright
looking she is pleasent enough
to look at a bit on the
heavy side but pleasent enough
she has a pretty face a bit
chubby but so was my mother
when she was alive when we
meet each other we are allways
under the weather drunk so we
are on the same wave lenth
and when your drunk you normally
go out looking for other people
that are the same as meself
beacuse when your drunk you need
a bit of company when your
sober i dont like anyone
comeing near me drunk

Iain Forsyth and Jane Pollard

Anyone Else Isn't You 2005

'If someone likes the Velvet Underground, there's a good chance that I'm going to like them', says a serious-looking young man in *Anyone Else Isn't You*. The video intercuts fourteen Londoners speaking about the central importance of music taste to their relationships – affiliations to favoured bands emerging as a common test when vetting potential dates.

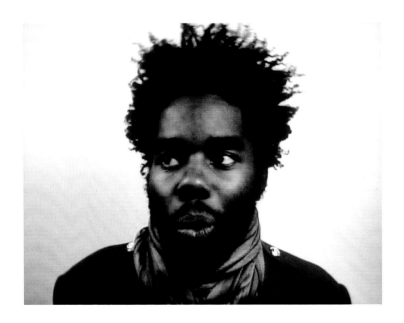

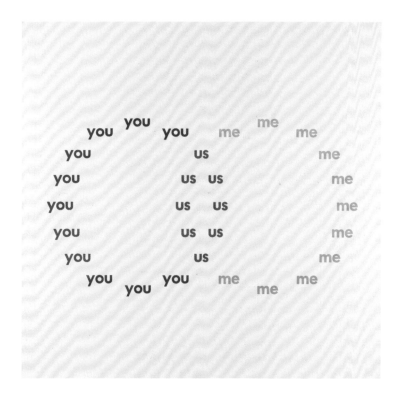

Bridget Bond

you me us 1966

Where 'you' and 'me' intersect to form 'us', primary colours fuse in a burst of green lettering. Bridget Bond's Venn diagram of pronouns seems to model an ideal of egalitarian love. Common territory may have claims on both 'you' and 'me', but each party retains autonomy over a greater remainder.

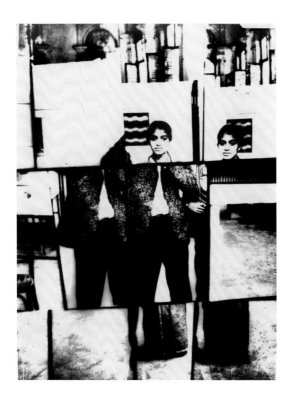

Jyoti Bhatt

Venice (or *Ardhanareshwar*) 1966

Images of artistic power couple Jyoti and Jyotsna Bhatt fragment in their kaleidoscopic Venetian selfie. The central shards reflect a composite body: Jyotsna's head, shoulders and feet with Jyoti's chest and thighs. Fittingly, the picture's alternative title, *Ardhanareshwar*, refers to an incarnation of divine couple Shiva and Parvati – represented in Hindu art as one harmonious, bi-gendered body.

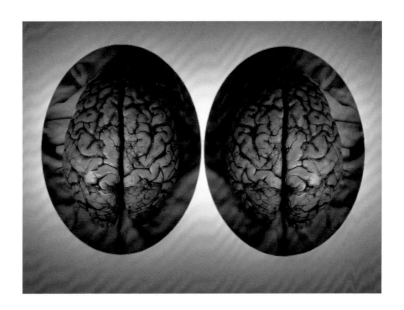

Helen Chadwick

Eroticism 1990

Two brains reclining on rumpled sheets remind us that sexuality is an affair of both mind and flesh. Helen Chadwick's ideal lovers, bearing no marks of sex, age or ethnicity, grant our imaginations free rein. But their too-perfect mirroring betrays a single, reflected image, perhaps alerting us that our objects of desire can be constructs of wishful thinking.

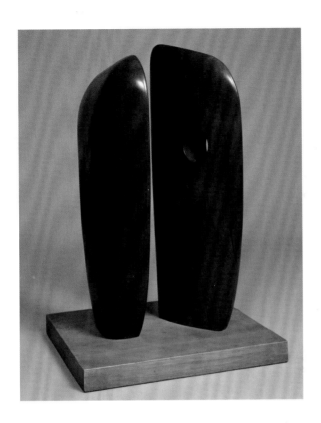

Barbara Hepworth

Forms in Echelon 1938

The polished fins of *Forms in Echelon* seem absorbed in each other's presence, a measure of Barbara Hepworth's gift for imbuing abstract sculpture with personality. A hole pierced through one form might suggest a lover's eye, open wide in appreciation, or perhaps a body receptive to touch – literally opening itself up.

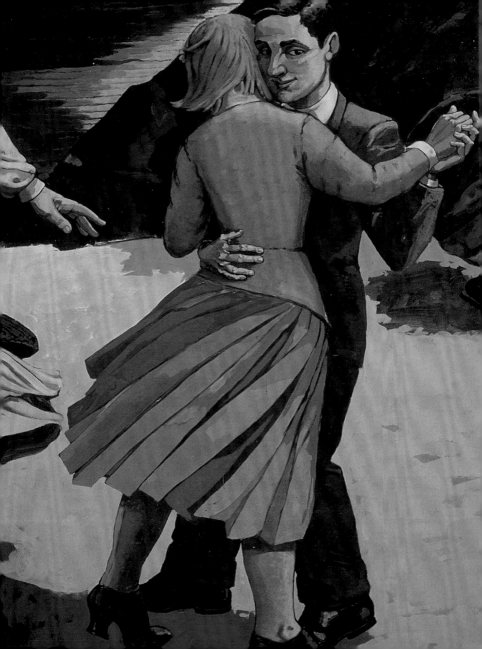

Holding On

Given time, one shadow encroaches upon the sunniest of relationships. Lovers' feelings for each other have no sway over their mortality and, at any point in their natural course, the most treasured companionships can be abruptly severed. When compounded by heartbreak, bereavement alters those left behind. Its cold impress begets unseen but nagging hollows, liable to twinge thereafter. Often, the one palliative for such grief is perpetual veneration – the departed now enshrined in memory, while the surviving lover assumes the role of head votary. This can go well beyond a metaphor when artists take their places among the bereft, perfectly equipped to conjure physical memorials to their lost loves. At such times, creation may come to serve as a profoundly personal act of devotion.

Love Locked Out – the artwork that opens this section – is a fine illustration of creative impulse arising from chronic mourning. The imposing tomb in the painting (p.89) could easily double as a temple to the memory of the artist's husband. Love might be locked out but we get the sense that, as chief priest in this exclusive cult, Anna Lea Merritt guards the key closely.

Opposite: Paula Rego, *The Dance* (detail, p.90)

Anna Lea Merritt
Love Locked Out 1889

Love Locked Out is a memorial on canvas, painted twelve years following
the death of Anna Lea Merritt's husband. The rose petals have withered,
the lamp has blown out and a distraught child, representing Love, presses
at the door of a tomb, desperate to be reunited with the spirit within.

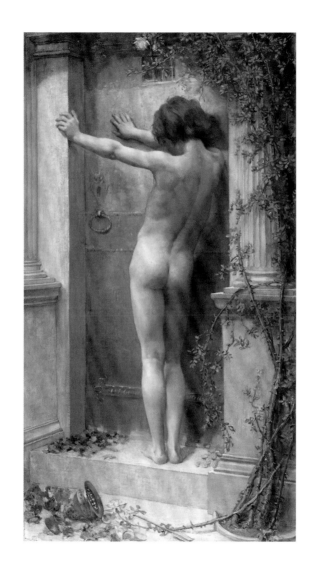

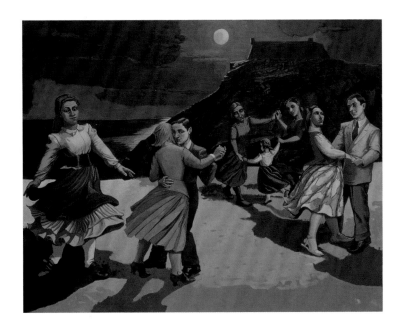

Paula Rego

The Dance 1988

Paula Rego began developing ideas for *The Dance* during her partner's final illness and has said the extended sketching process helped her to handle bereavement. Outnumbered by women at varying stages of life, Rego's suave male dancers – one resembling her late husband – are transitory players in this circular dance.

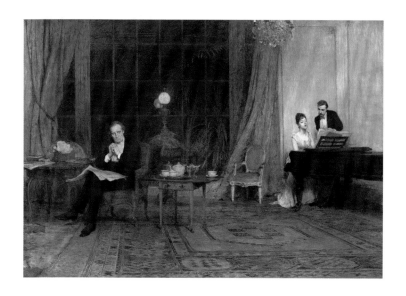

William Quiller Orchardson

Her Mother's Voice exhibited 1888

The pivot of William Quiller Orchardson's painting eludes our powers
of vision. A jowly, bourgeois widower turns from his evening paper to
commune privately with her spectral presence. His daughter, meanwhile,
is in danger of fading into the drawing room walls, eclipsed by the ghostly
beloved her own performance has summoned.

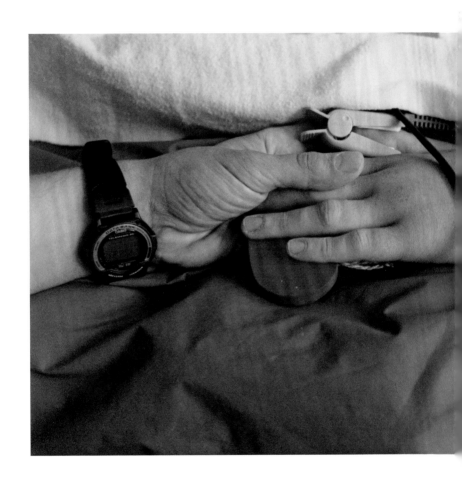

Wolfgang Tillmans

Für Immer Burgen 1997

Like the central band of an accidental flag, two
hands link across hospital sheets. That belonging
to artist Wolfgang Tillmans gently enfolds its paler,
puffy companion, unwilling to let go. Jochen Klein
succumbed to AIDS-related illness on the same day
his partner's camera preserved this ensign for lovers.

Featured Works

Bandele 'Tex' Ajetunmobi
*Couple Kissing, Whitechapel,
London* c.1960s, printed 2012
Photograph, gelatin silver print
on paper, 28 × 28
P14367, Gift Eric and Louise
Franck London Collection 2016,
p.25

Lawrence Alma-Tadema
A Foregone Conclusion 1885
Oil paint on wood, 31.1 × 22.9
N03513, Bequeathed by Amy,
Lady Tate 1920, p.37

Rasheed Araeen
Lovers 1968
Painted wood, 91.4 × 91.4 × 91.4
T13389, Presented by Tate
Members 2011, p.61

Maria Bartuszová
Untitled 1971
Plaster, 12 × 12 × 40
T14519, Purchased with funds
provided by the Edward and
Agnès Lee Acquisition Fund
2016, p.60

Jyoti Bhatt
Venice (or *Ardhanareshwar*)
1966
Photograph, gelatin silver print
on paper, 29.1 × 21.9
P81233, Purchased with funds
provided by the South Asia
Acquisitions Committee 2015, p.74
(detail) and p.83

William Blake
*The Circle of the Lustful:
Francesca da Rimini ('The
Whirlwind of Lovers')*
1826–7, reprinted 1892
Line engraving on paper,
24.3 × 33.5
A00005, Purchased with the
assistance of a special grant
from the National Gallery and
donations from the Art Fund,
Lord Duveen and others, and
presented through the Art Fund
1919, p.23

Bridget Bond
you me us 1966
From *Experiments in
Typography*
Letterpress print on paper, 48 × 48
P80721, Presented by Tate
Members 2013, p.82

Louise Bourgeois
Couple I 1996
Fabric, hanging piece,
203.2 × 68.5 × 71.1, 15 kg
AL00344, ARTIST ROOMS
Tate and National Galleries of
Scotland. Lent by the Artist
Rooms Foundation 2013, p.48

Edward Burne-Jones
Desiderium 1873
Graphite on paper, 21 × 13.3
N02760, Presented by Sir Philip
Burne-Jones Bt 1910, p.17

Philip Hermogenes Calderon
Broken Vows 1856
Oil paint on canvas, 91.4 × 67.9
N05780, Purchased 1947, p.65

Sophie Calle
The Hotel, Room 29 1981
2 works on paper, photographs
and ink, displayed: 214 × 142
P78302, Presented by the Patrons
of New Art through the Tate
Gallery Foundation 1999, p.43

Edward Calvert
The Chamber Idyll 1831
Wood engraving on paper,
4.1 × 7.6
A00161, Presented by S. Calvert
1912, pp.50–1

Helen Chadwick
Eroticism 1990
2 transparencies on light boxes,
76 × 122 × 23
T07411, Purchased 1998, p.84

Ithell Colquhoun
Scylla 1938
Oil paint on board, 91.4 × 61
T02140, Purchased 1977, p.55

**Susanna Duncombe (née
Susanna Highmore)**
*Vignette with Cupids and a
Courting Couple in a Library*
n.d.
Graphite and ink on paper,
9.4 × 11.2
T04260, Presented by Mrs Joan
Highmore Blackhall and Dr R.B.
McConnell 1986, p.14

Tracey Emin
Is Anal Sex Legal 1998
Neon lights, 32.5 × 155 × 10
T11890, Purchased 2004, p.29

Is Legal Sex Anal 1998
Neon lights, 34 × 158 × 10
T11889, Purchased 2004, p.29

**Iain Forsyth
Jane Pollard**
Anyone Else Isn't You 2005
Video, monitor or flat screen,
black and white, and sound
(mono), 30 min
T12455, Purchased 2007, p.81

Felix Gonzalez-Torres
"Untitled" (Double Portrait)
1991
Print on paper, endless copies
26 at ideal height × 100 × 70
(original paper size)
T13309, Purchased jointly by
Tate, with assistance from the
American Patrons for Tate and
the Latin American Acquisitions
Committee; and Albright-Knox
Art Gallery, Buffalo 2010, p.45

Barbara Hepworth
Forms in Echelon 1938
Tulipwood on elm base,
108 × 60 × 71
T00698, Presented by the artist
1964, p.85

Lubaina Himid
Ankledeep 1991
From the series *Revenge:
A Masque in Five Tableaux*
Acrylic paint on canvas,
152.4 × 121.9
T12885, Presented by the artist
2009, p.20 (detail) and p.31

David Hockney
In the Dull Village
from *Illustrations for Fourteen
Poems from C.P. Cavafy* 1966–7
Etching, 34.5 × 22.3
P77570, Purchased 1992, p.15

Dorothy Iannone
Wiggle Your Ass for Me 1970
Acrylic paint on canvas, mounted
on canvas, 190.4 × 150
T14984, Purchased using funds
provided by the 2017 Frieze Tate
Fund supported by WME | IMG
2018, p.57

Gwen John
Dorelia in a Black Dress
c.1903–4
Oil paint on canvas, 73 × 48.9
N05910, Presented by the
Trustees of the Duveen Paintings
Fund 1949, p.27

Arthur Lemon
The Wooing of Daphnis
exhibited 1881
Oil paint on canvas, 85.2 × 120
T07562, Presented by Daya
Moonesinghe 1999, pp.12–13

Richard Lin
Flirtation 1965
Screenprint on paper, 44.1 × 56.2
P04572, Presented by Rose and
Chris Prater through the Institute
of Contemporary Prints 1975, p.16

Linder
Untitled 1976
Printed papers on paper,
27.9 × 19.6
T12498, Purchased 2007, p.10
(detail) and p.19

Agnes Martin
Faraway Love 1999
Acrylic paint and graphite on
canvas, 152.5 × 152.5
AR00178, ARTIST ROOMS
Acquired jointly with the
National Galleries of Scotland
through The d'Offay Donation
with assistance from the National
Heritage Memorial Fund and the
Art Fund 2008, p.71

Anna Lea Merritt
Love Locked Out 1889
Oil paint on canvas, 115.6 × 64.1
N01578, Presented by the Trustees
of the Chantrey Bequest 1890,
p.89

John Everett Millais
Mariana 1851
Oil paint on mahogany,
59.7 × 49.5
T07553, Accepted by HM
Government in lieu of tax and
allocated to the Tate Gallery
1999, p.64

Ron Mueck
Spooning Couple 2005
Mixed media, 14 × 65 × 35
AR00033, ARTIST ROOMS
Acquired jointly with the
National Galleries of Scotland
through The d'Offay Donation
with assistance from the National
Heritage Memorial Fund and
the Art Fund 2008, p.62 (detail)
and p.73

Catherine Opie
*Melissa & Lake, Durham, North
Carolina* 1998
From *Domestic*
Photograph, C-print on paper,
mounted on aluminium, 100 × 126
P20848, Presented by the artist
2017, p.32 (detail) and p.41

William Quiller Orchardson
Her Mother's Voice exhibited
1888
Oil paint on canvas, 101.6 × 148.6
N01521, Presented by Sir Henry
Tate 1894, p.91

Charlie Phillips
Notting Hill Couple 1967
Photograph, gelatin silver print
on paper, 26.1 × 37.4
P13813, Gift Eric and Louise
Franck London Collection 2013,
pp.4–5 (detail) and pp.76–7

Paula Rego
The Dance 1988
Acrylic paint on paper on canvas,
212.6 × 274
T05534, Purchased 1989, p.86
(detail) and p.90

Auguste Rodin
The Kiss 1901–4
Pentelican marble,
182.2 × 121.9 × 153
N06228, Purchased with
assistance from the Art Fund and
public contributions 1953, p.6

Cindy Sherman
Untitled Film Still #27 1979
Gelatin silver print
23.5 × 16.5
P11517, Presented by Janet
Wolfson de Botton 1996, p.67

Sylvia Sleigh
The Bride (Lawrence Alloway)
1949
Oil paint on canvas, 61 × 50.8
T14280, Purchased with the
support of the Estate of Sylvia
Sleigh 2015, p.39

Simeon Solomon
*Sappho and Erinna in a Garden
at Mytilene* 1864
Watercolour on paper, 33 × 38.1
T03063, Purchased 1980, p.46
(detail) and pp.52–3

Marcus Stone
Il y en a toujours un Autre 1882
Oil paint on canvas, 153.7 × 70.5
N01583, Presented by the
Trustees of the Chantrey Bequest
1882, p.69

Parviz Tanavoli
The Poet and the Beloved of the King 1964–6
Wood, tin-plate, copper, steel, fluorescent light, Perspex and oil paint, 189.7 × 108 × 107
T13684, Purchased with funds provided by Edward and Maryam Eisler 2012, p.70

Wolfgang Tillmans
Für Immer Burgen 1997
Photograph, colour, Chromogenic print, on paper, 30.5 × 40.6
P79258, Presented by Tate Patrons 2007, pp.92–3

Unknown artist, Britain
Lovers Meeting by Moonlight in a Garden 1869
Watercolour and gouache on paper, 40.4 × 28.9
T09600, Purchased as part of the Oppé Collection with assistance from the National Lottery through the Heritage Lottery Fund 1996, p.24

Andy Warhol
Tongue in Ear 1982
Graphite on paper, 80 × 60
AR00595, ARTIST ROOMS
Acquired jointly with the National Galleries of Scotland through The d'Offay Donation with assistance from the National Heritage Memorial Fund and the Art Fund 2008, p.49

Gillian Wearing
Theresa and George 1998
2 photographs, colour, Chromogenic print, on paper
Each 51 × 51 (detail, p.79)
P78344, Purchased with assistance from the Gytha Trust 2000, pp.78, 79

Francesca Woodman
Untitled 1975–80
Photograph, gelatin silver print on paper and ink on paper, 25.3 × 20.2
AR00347, ARTIST ROOMS
Acquired jointly with the National Galleries of Scotland through The d'Offay Donation with assistance from the National Heritage Memorial Fund and the Art Fund 2008, p.59

Christopher Wool
Untitled 1997
Enamel on aluminium
274.3 × 182.9
T12905, Presented by the American Fund for the Tate Gallery, courtesy of Donald L. Bryant Jr and family in memory of Monique Beudert 2009, p.35

Akram Zaatari
Objects of study: Hashem el Madani, Studio Practices 2007
Photograph, gelatin silver print on paper, 39.1 × 26.5
P79451, Presented by Tate International Council 2008, p.40